THE Wild LIFE OF Dogs

A **RUBES**® CARTOON BOOK BY LEIGH RUBIN

BOWTIE™ PRESS

IRVINE, CALIFORNIA

For Stanley and Natalie

Ruth Strother, Project Manager
Nick Clemente, Special Consultant
Michelle Martinez, Editor; Karla Austin, Associate Editor
Michael Vincent Capozzi, Designer

Library of Congress Control Number: 2002109942

BowTie™ Press
A DIVISION OF FANCY PUBLICATIONS
3 Burroughs
Irvine, California 92618
949-855-8822

Printed and Bound in Singapore
10 9 8 7 6 5 4 3 2 1

Foreword

Thousands of years ago, scientists speculate that a hungry wolf, lured by the smell of a primitive barbecue, ventured up to a prehistoric chef, and for his boldness and curiosity was rewarded with the bones and charred scraps of some unlucky herbivore.

Not much has changed since then, except, of course, that we've traded in fire for the microwave, and over time we've changed some wolves through the magic of selective breeding to dogs.

If I could travel back in time, I'd gladly shake the hand of that chef and the paw of that wolf. Together they altered the course of history and changed their world, and ours, for the better.

Leigh Rubin

4

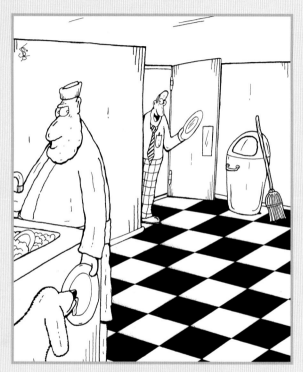

"The County Health Inspector is having lunch.
Make sure his plate is extra clean."

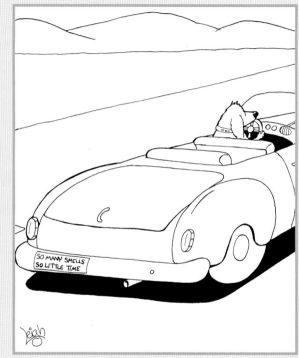

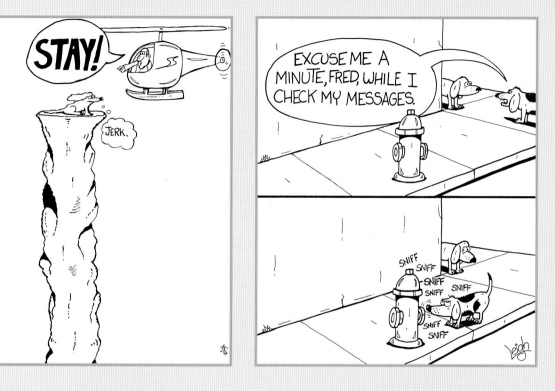

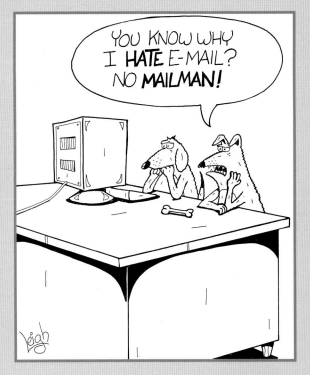

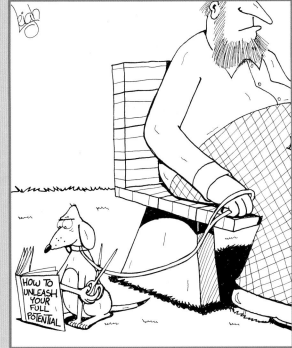

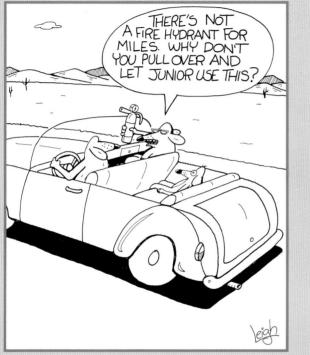

Canine port-a-potties

When dogs retire

"Let me get this straight. I'm paying *you* a hundred bucks an hour, and you're telling me *I'm* not even allowed to lie on the couch?!"

"What a complete waste. The very latest in state-of-the-art, high-definition color technology and we can see it only in black and white."

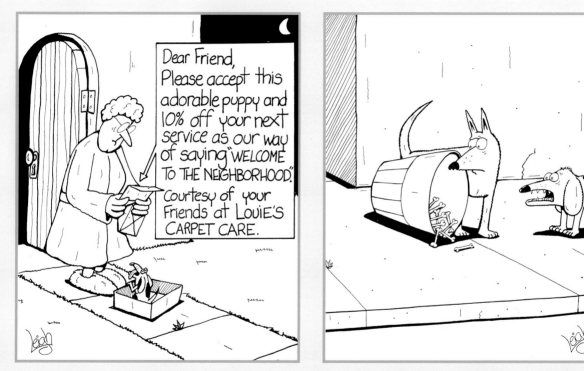

"I just don't understand people. They order a bucket of chicken but throw away the best part."

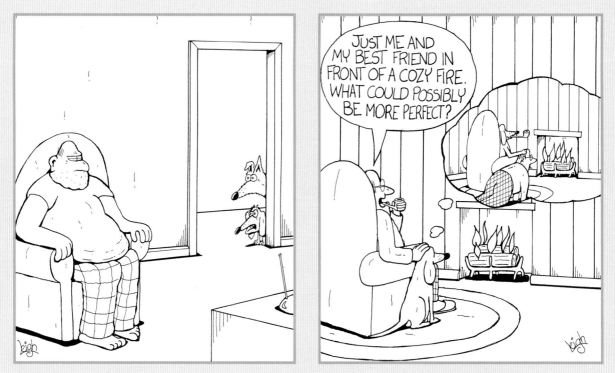

"Technically I'm a lap dog. But as you can see,
the only lap around here is occupied."

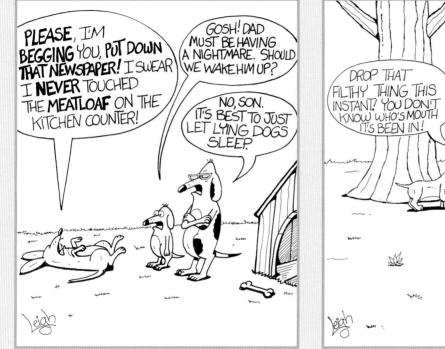

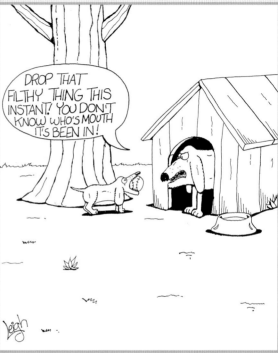

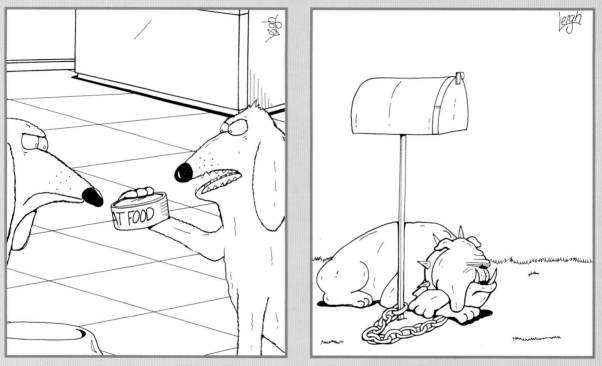

"What a rip-off! Where do they come off calling this stuff cat food? Just look at the ingredients—there's not any cat in it!"

How to put a stop to all of that annoying junk mail.

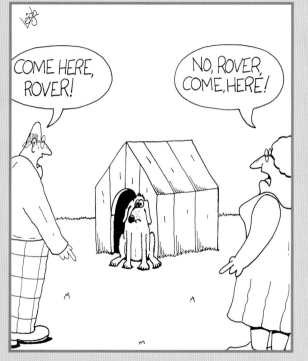

Rover discovers the age-old truth—no one can serve two masters.

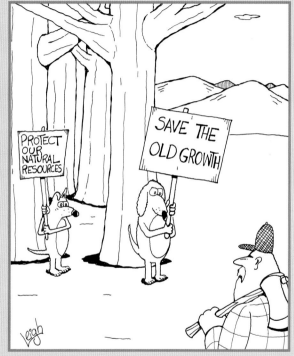

Though it was an admirable cause, many cynics strongly suspected that the protesters were in it purely for self-serving reasons.

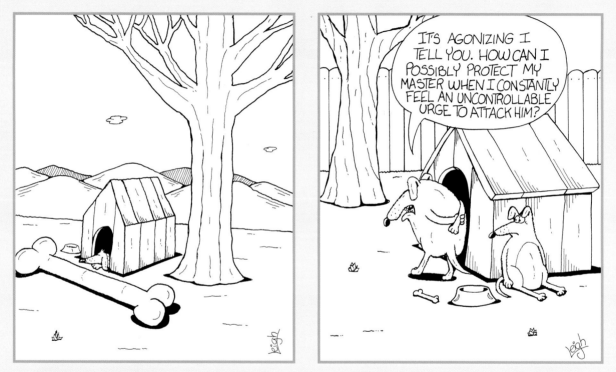

There were distinct advantages to being the Museum of Natural History curator's pet.

The moral dilemma of a mailman's dog.

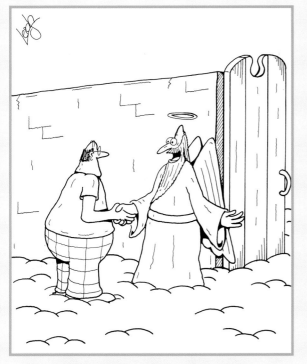

"Congratulations, Bob, you made it!
Just watch your step, as I'm sure you've heard
by now, all dogs go to heaven."

A watchdog committee was called in to determine
whether the fight or the fighter had been fixed.

"What it really comes down to is a question of values. Is a delicious, succulent turkey, baked to perfection worth a few whacks on the nose with a newspaper?"

"Nope, no sign of your kitten, ma'am. But to be absolutely certain, we'd better perform a CAT scan."

There was no end in sight to his compulsive tail chasing. It was a vicious circle.

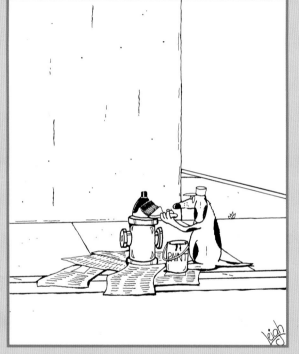

Canine bathroom remodeling

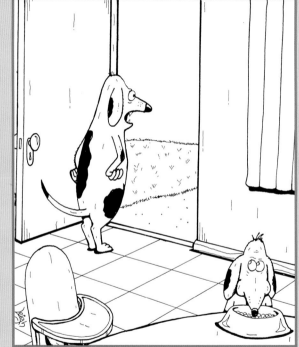

The good news is that Junior's finally housebroken. The bad news is that he still prefers the morning paper."

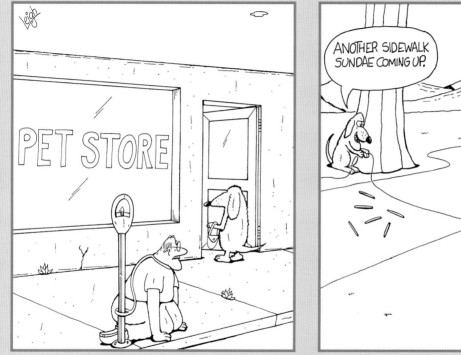

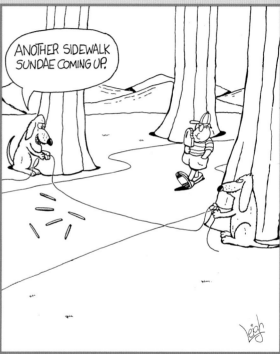

Ralph wished he could go out and have fun like the other dogs, but unfortunately he was allergic to cats.

"Well, what are you waiting for, you stupid moron? Jump!"

Old Mother Hubbard before her mysterious disappearance.

In retrospect, achieving his childhood dream didn't seem quite as appealing as he had imagined.

"In order to adequately demonstrate just how many ways there are to skin a cat, I'll need a volunteer from the audience."

"I know darn well you weren't just out 'roaming the neighborhood with your buddies.' That's not my scent on your collar!"

"Remember this? Boy, that was some
Thanksgiving!"

"My license, officer? Uh, Ha! Ha! I must have
left it on my other collar!"

"Great. Your know what this means? Overpriced food, small portions, and no doggy bags."

"There, there, I know how attached you were to him. Why, he was almost one of the family. But cheer up, son. We'll get you a new master."

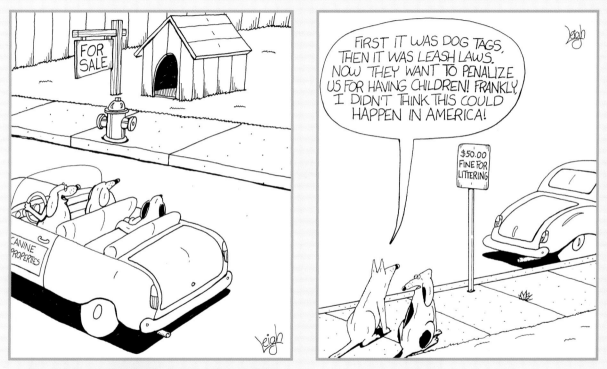

"It's a lovely little starter home. And with the fire hydrant conveniently located out front, I'm sure you'll agree it's got lots of curb appeal."

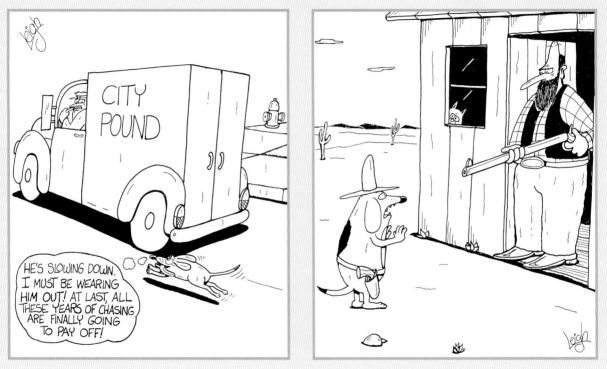

"Easy now, mister. I have no quarrel with you—
it's your cat I'm after."

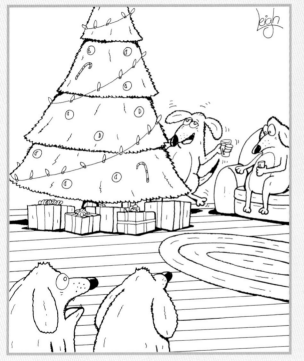

"There goes Uncle Albert again. A couple of drinks and he completely forgets he's housetrained."

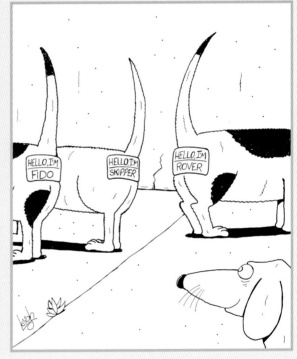

Canine mixers

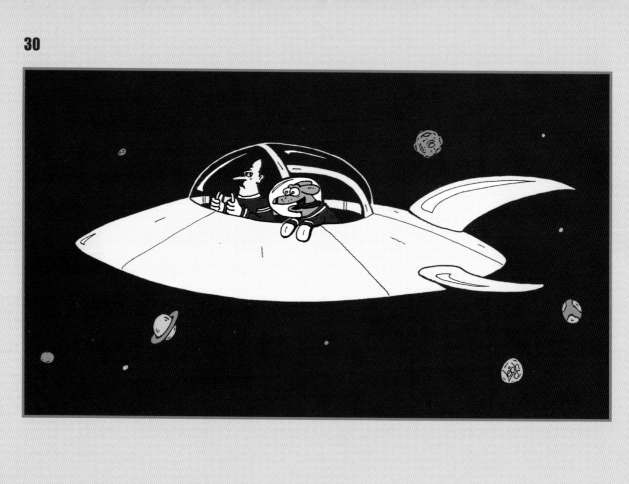

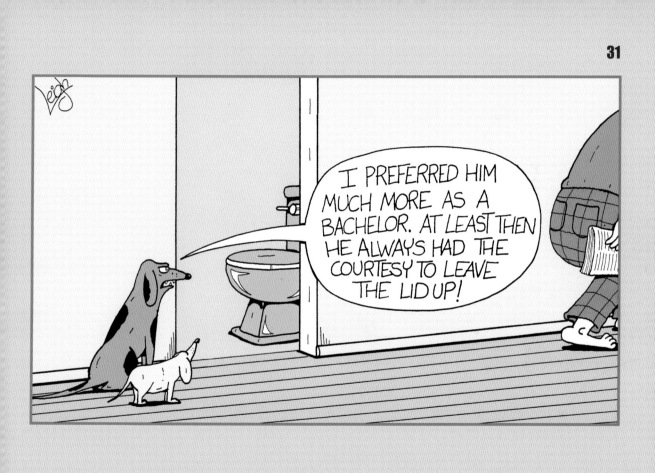

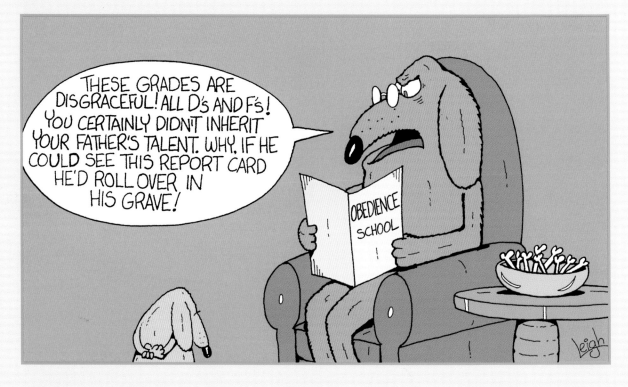

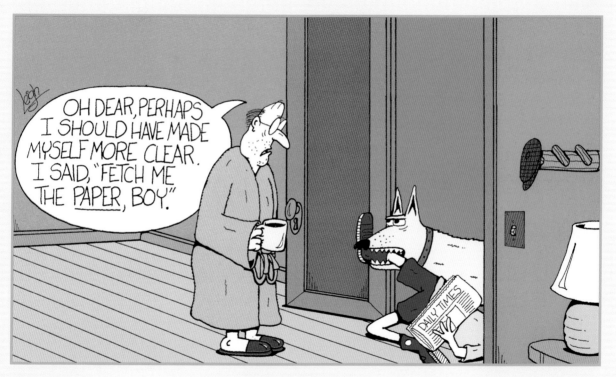

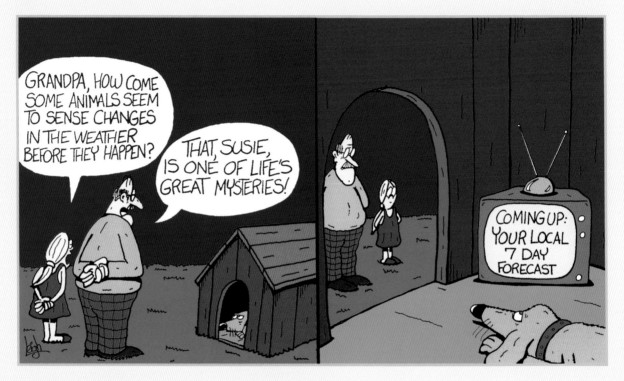

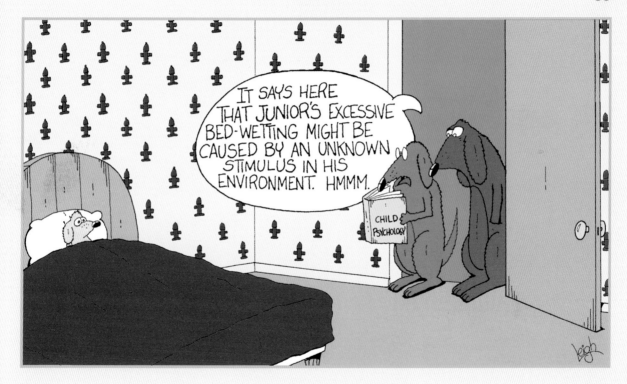

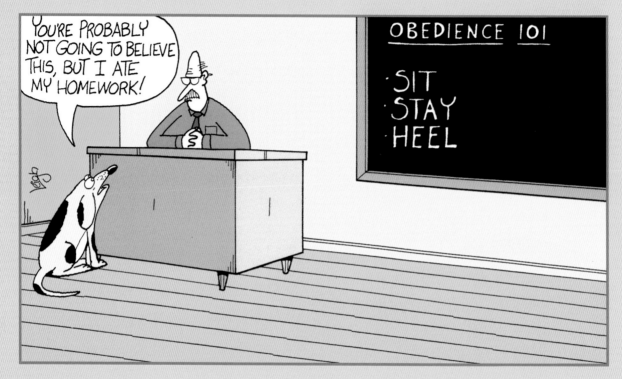

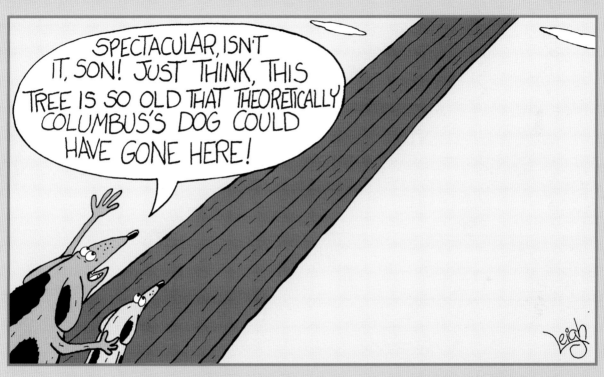

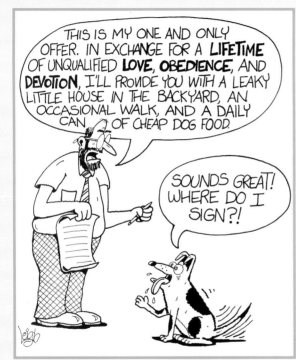

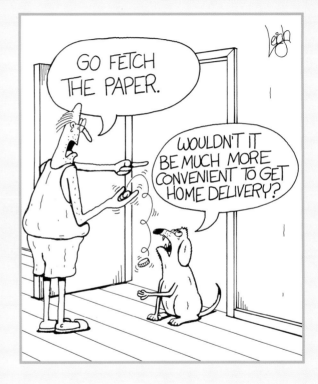

Dogs—great pets, lousy negotiators.

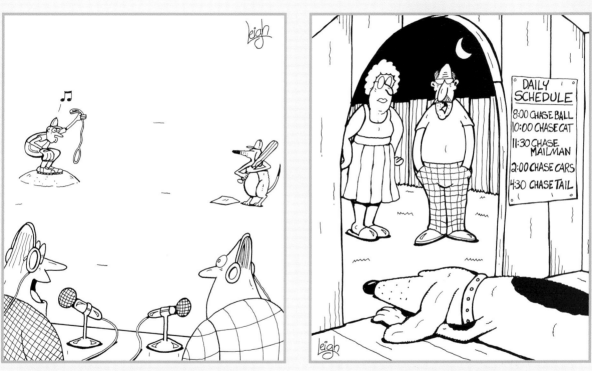

"Well, Bob, it definitely looks like Johnson
is going to attempt to walk the batter."

"Boy, what a life. What I wouldn't give to just
lie around all day!"

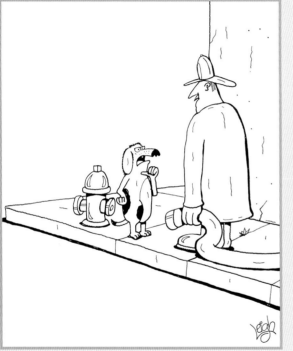

"Listen, pal, I don't care how badly you have
to use this thing. I've got a little emergency
of my own!"

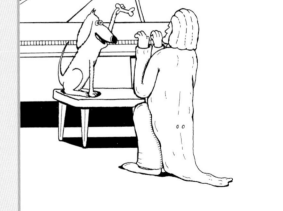

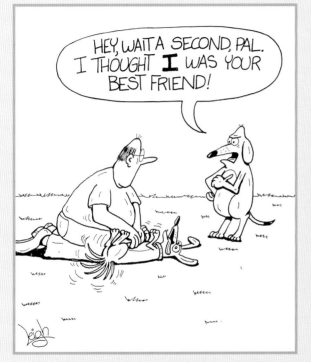

The major drawback of owning more than
one dog.

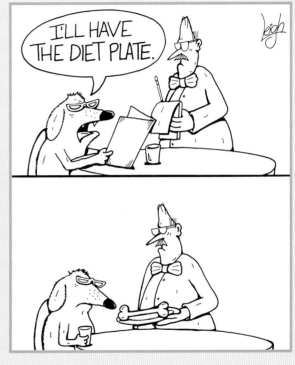

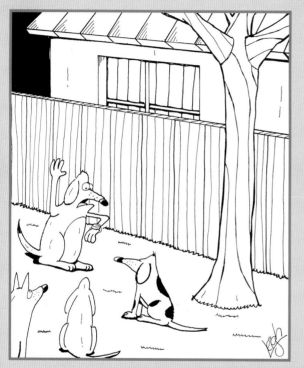

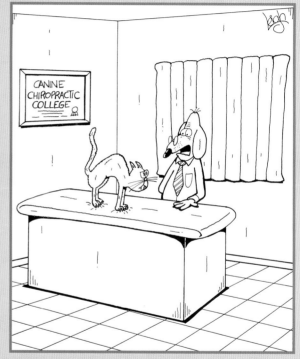

"Ok, fellas, we can hold up on the barking. It's about time for the neighborhood to wake up."

"Now just try and relax. I can't possibly adjust your spine if you keep arching it at me like that!"

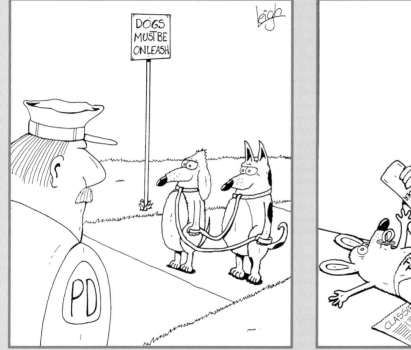

Officer Johnson runs into one of those "gray areas" of the law.

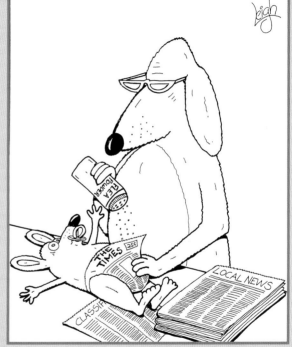

Harriet enjoyed the ease and convenience of subscribing to a daily diaper-delivery service.

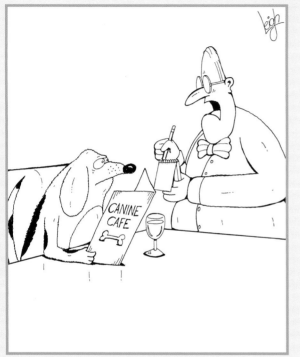

"Would you like me to serve your steak at the table, or would you prefer to sneak into the kitchen, climb up on the counter, and serve yourself?"

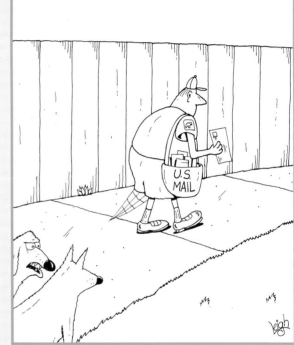

"Oh, I suppose we could chase him, but there's really no sport in it. He's so pitifully slow."

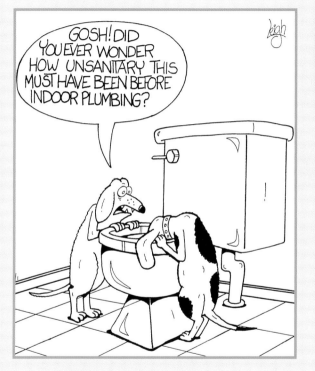

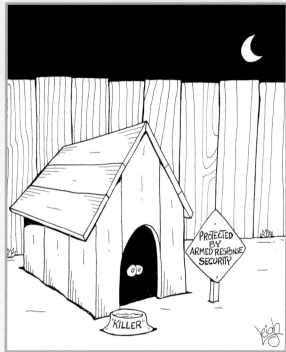

How to tell you're in a very rough neighborhood.

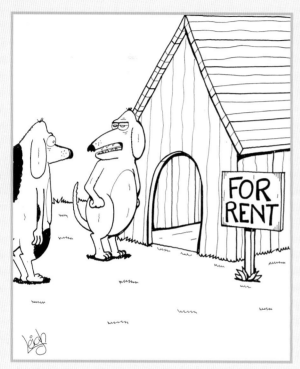

"No, I'm afraid it doesn't come furnished. What's the point? You're not allowed on the furniture anyway."

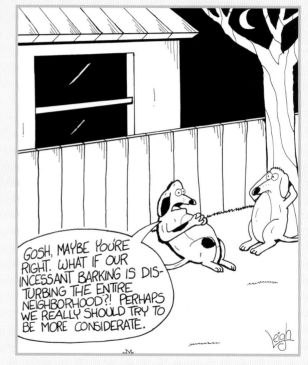

What dogs would be like in a perfect world.

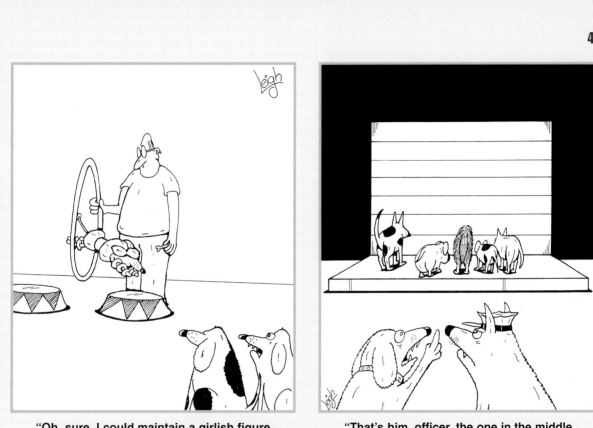

"Oh, sure, I could maintain a girlish figure
like hers if I had a personal trainer."

"That's him, officer, the one in the middle.
I never forget a scent!"

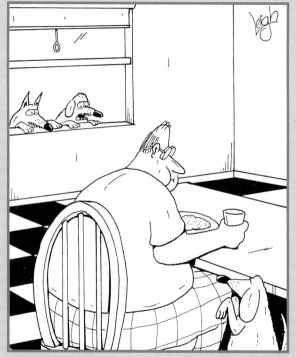

"I don't know how Ralph can put up with a vegetarian owner. Just think of the humiliation of having to beg for tofu and bean sprouts."

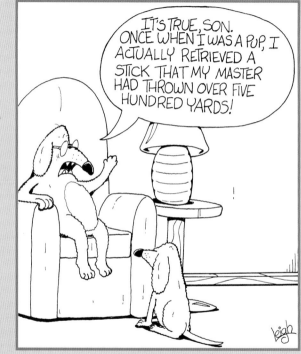

Gramps tells another one of his far-fetched tales.

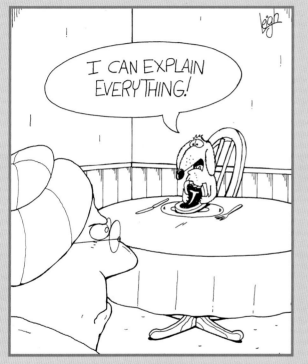

The dog equivalent of "getting caught with the other woman."

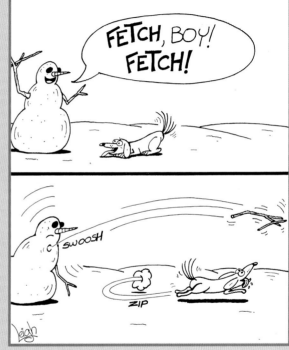

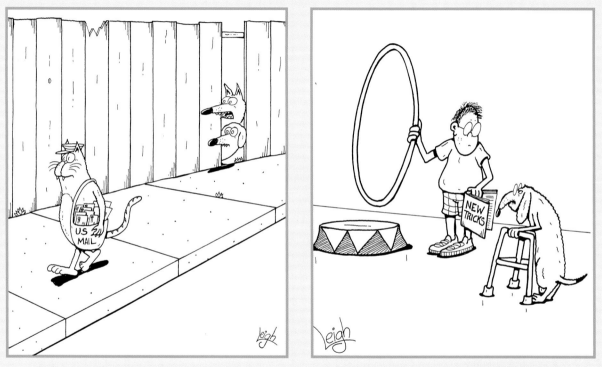

"Either I'm dreaming, Louie, or we hit the jackpot!"

Harold discovers that there is apparently some truth to the old adage.

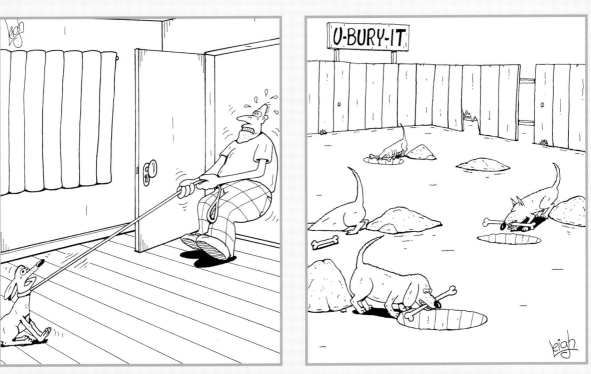

"No way, man! I don't need obedience training,
and you can't make me go!"

Canine public storage

"Then it's a deal. You don't say nothin' about the meatloaf, and I don't say nothin' about the canary."

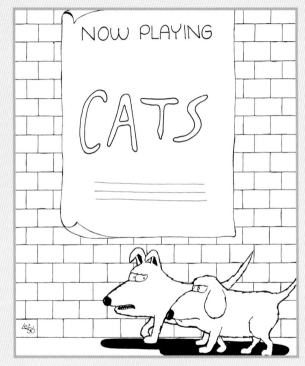

"I thought it was lousy."

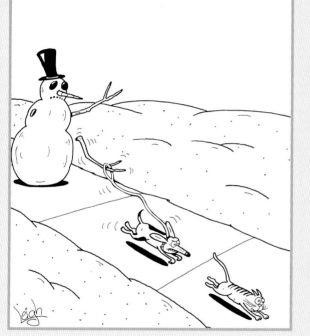

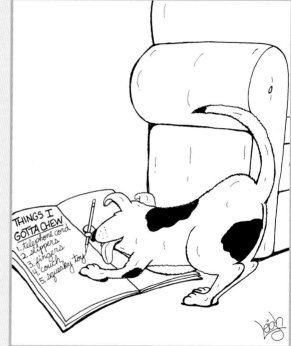

Puppy day planners

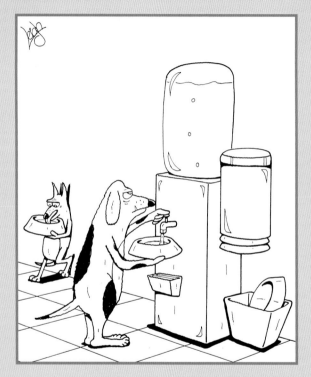

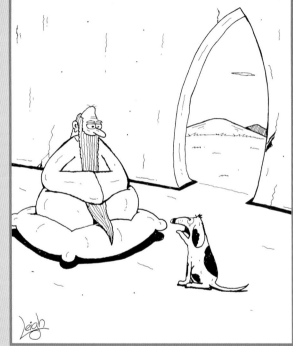

"Apparently, there's been a misunderstanding.
I'm not lost spiritually, I just can't find my
way home."

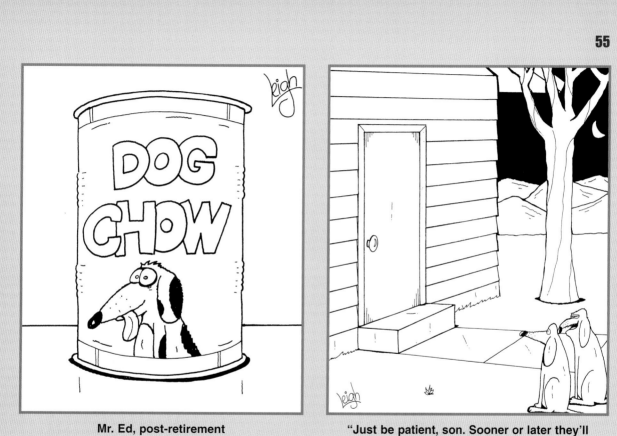

Mr. Ed, post-retirement

"Just be patient, son. Sooner or later they'll
have to put the cat out for the night."

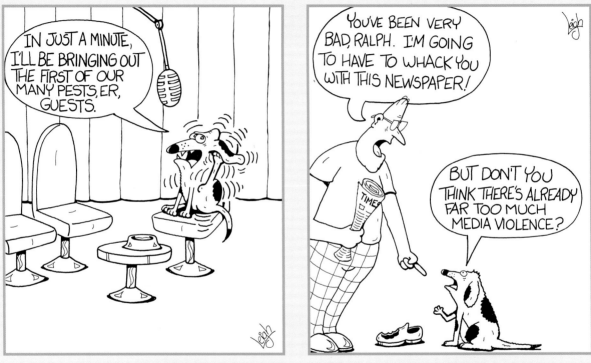

Being the host of "Parasites Today" was not without its drawbacks.

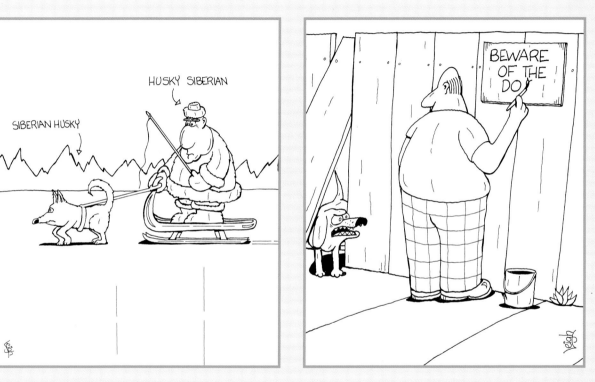

"Ok, boy, let's try it again."

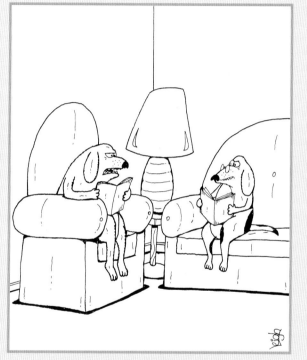

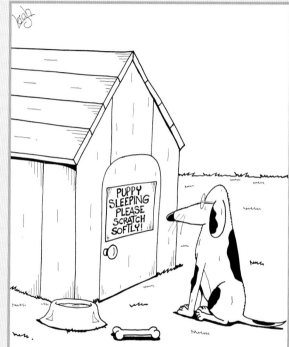

"For the last time, Harriet. If a puppy will make you happy, go ahead and have one. Just don't expect me to be the one to clean up after it."

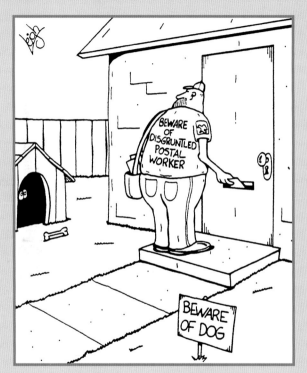

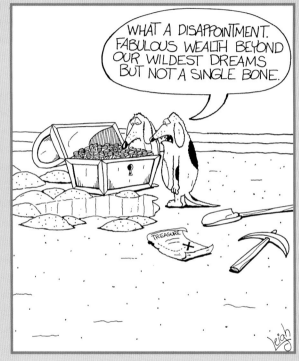

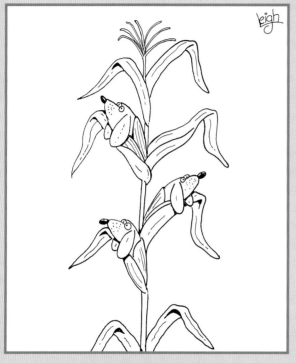

An important crop feeding a nation of hungry carnival goers—the corn dog.

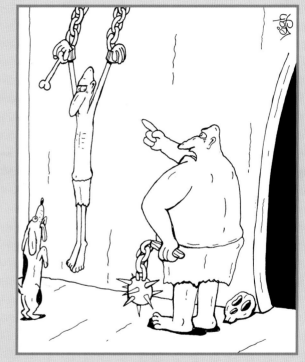

"Hey, knock it off, Buddy! We don't tolerate cruelty to animals around here!"

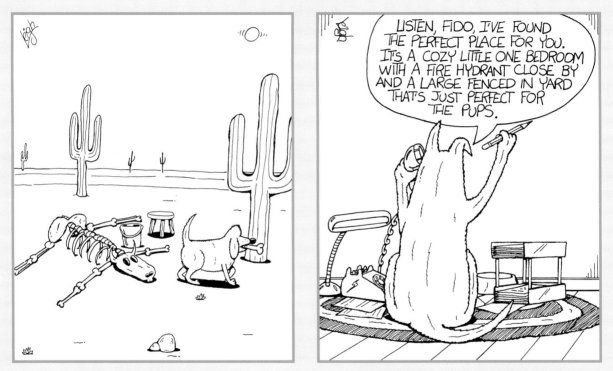

Where milk bones come from.

Rover did his business on the carpet.

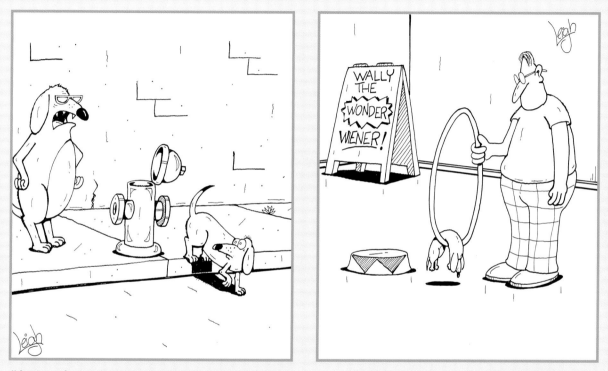

"Just a minute, young man! How many times have I told you to close the lid when you're done?!"

Harold's lifelong dream of developing a successful circus act was never to be realized.

Leigh Rubin has been creating RUBES® cartoons for eighteen years. They now appear in hundreds of newspapers worldwide and grace millions of greeting cards, mugs, T-shirts, and dog bowls. Leigh is the author of ten books, including *The Wild Life of Pets*, *Rubes Bible Cartoons*, and the award-winning *Rubes-Then and Now*. Leigh is married and has three sons.

BowTie™ Press is a division of Fancy Publications, which is the world's largest publisher of pet magazines. For further information on your favorite pets, look for *Dog Fancy*, *Dogs USA*, *Cat Fancy*, *Cats USA*, *Horse Illustrated*, *Bird Talk*, *Reptiles*, *Aquarium Fish*, *Rabbits*, *Ferrets USA*, and many more.